DOUBLE EXPOSURE

EVERYDAY BEAUTY

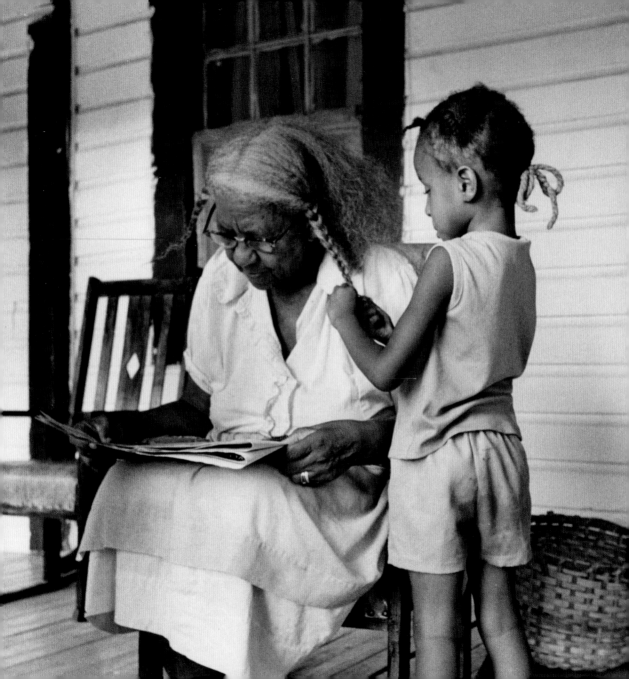

DOUBLE EXPOSURE

EVERYDAY BEAUTY

Photographs from the National Museum of
African American History and Culture

NATIONAL MUSEUM
OF AFRICAN AMERICAN
HISTORY & CULTURE

Earl W. and Amanda Stafford
Center for African American Media Arts

GILES

National Museum of African American History and Culture
Smithsonian Institution, Washington, D.C., in association with D Giles Limited, London

For the National Museum of African American History and Culture
Series Editors: Laura Coyle and Michèle Gates Moresi

Editorial Assistant: Douglas Remley

Curator and Head of the Earl W. and Amanda Stafford Center for African American Media Arts: Rhea L. Combs

Publication Committee: Aaron Bryant, Rhea L. Combs, Laura Coyle, Michèle Gates Moresi, Loren E. Miller, Douglas Remley, and Jacquelyn Days Serwer

For D Giles Limited
Copyedited and proofread by Jodi Simpson
Designed by Alfonso Iacurci
Produced by GILES, an imprint of D Giles Limited, London
Bound and printed in Hong Kong

All measurements are in inches and centimeters; height precedes width precedes depth.

Photograph titles: Where a photographer has designated a title for his/her photograph, this title is shown in italics. All other titles are descriptive, and are not italicized.

Front cover: *Eddie Mitchell, Unemployed Youth, Birmingham, Alabama,* 1940 (detail), Arthur Rothstein
Back cover: *NYC,* 1970s, Anthony Barboza
Frontispiece: *Quilter Hettie Barnes with Her Granddaughter on Her Front Porch in Doloroso, near the Homochitto River in Wilkinson County, Mississippi,* 1976 (detail), from the series *Mississippi Folklife Project,* Roland L. Freeman
Page 6: *Untitled,* 1946–48 (detail), A railroad passenger car maintenance man, from the series *The Way of Life of the Northern Negro,* Wayne F. Miller

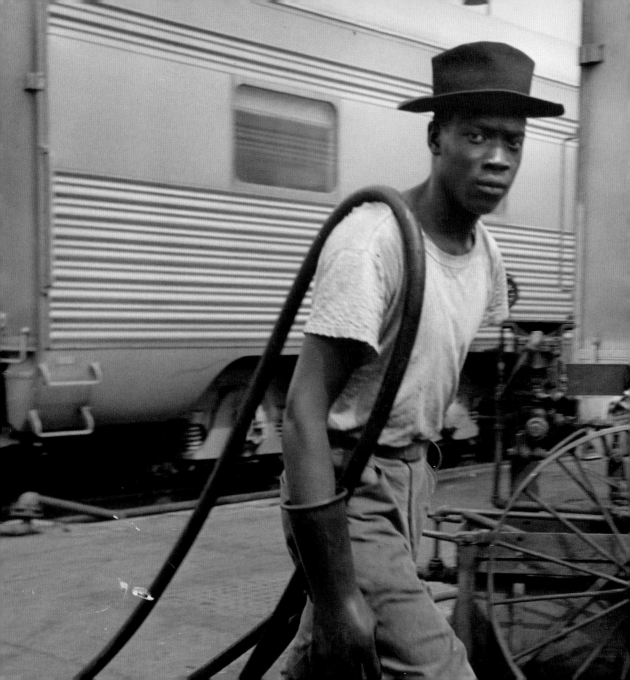

Foreword

Wayne F. Miller's photograph of a railroad car maintenance man (opposite; see also p. 64) strikes me as a revealing, and beautiful, view into everyday life. Our lives are the sum of the everyday—our work, our play, our intimate moments and social engagements, the triumphs and the tragedies—and in each experience there is beauty.

This is one of 54 photographs from Miller's portfolio *The Way of Life of the Northern Negro*, created during 1946-48, which captures the textures of urban life for African Americans in mid-century Chicago. African Americans played a crucial role in the booming industries of the city, from the hum of the steel mills to the beat of blues and jazz clubs. Through Miller's eyes we see a railroad maintenance worker—a person who ensured the flow of people and goods through the bustling city—as a man who walks with confidence, strength, and dignity. That he projects such a demeanor in the context of segregated life in the congested streets of the second-largest city in the nation is telling. By many reports, black Chicagoans were living a hard life in the overcrowded and underserved neighborhoods, then derogatively called ghettos, overwhelmed by the waves of southern migrants who sought equality, better jobs, and new opportunities. Representations in photographs and film of black communities in such urban areas often reinforced negative images of defeatism, criminality, and deprivation, reducing the people who lived there to one-dimensional stereotypes. Yet, this man's determined, level gaze suggests he is an individual, a man with personality, hopes, and desires. There is a fundamental beauty in that reality and this image.

As Miller had served in World War II, witnessing its horrors firsthand, he was motivated to use his lens to see the humanity of ordinary people and to capture such moments in photographs. Although he was a native of Chicago, as a white man he knew little of the segregated Bronzeville neighborhood on the South Side and sought to discover it. He managed to capture what he sought: universal truths of human experience—we all laugh and cry, have dreams and feel pride, seek the comforts of home and the tenderness of love. I am proud to say we hold this powerful portfolio in the permanent collection of the National Museum of African American History and Culture (NMAAHC) and present two of its images in this volume (see pp. 46 and 64).

Almost as soon as photography was invented, African Americans hired photographers and took cameras into their own hands, seizing the opportunity to create their own pictures. Thousands of photographs in the Museum's collection show that this

effort to shape one's own image has never gone away. Like anyone else, African Americans use photography to capture likenesses and events, large and small, and to show their best selves: well groomed, confident, prosperous, and beautiful. Nevertheless, for black Americans, who were and often still are bombarded with negative, demeaning images of themselves, these photographs are evidence of their humanity. The snapshots and portraits African Americans posed for, produced, shared, and treasured attest that they, too, are engaged in this beautiful, difficult endeavor called life, each with his or her own story. At the same time, many of these photographs celebrate African Americans' cultural identity: particular ways of dressing, playing, and posing that unabashedly say, "I'm black, and I'm proud." In everyday photographs that reflect self-determination and self-definition, power—precious and hard won—is a special kind of beauty.

With this sixth volume of our *Double Exposure* series, we explore the theme of everyday beauty, which highlights a key element in the Museum's collection of photographs—finding the extraordinary in the ordinary, seeing the beauty in the everyday, and making visible our humanity. This selection is inspired by the photography exhibition of the same name, curated by Rhea L. Combs, and displayed in the Earl W. and Amanda Stafford Center for African American Media Arts (CAAMA). Operating as both a

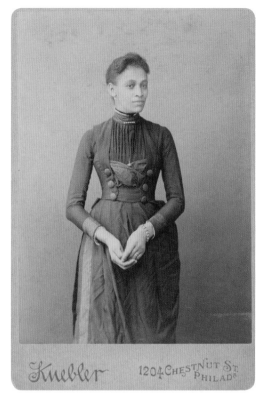

A woman, 1885–92
William J. Kuebler Jr.

physical and visual resource in the Museum, CAAMA offers unique access to the Museum's photography and film collection. Likewise, the volumes of the *Double Exposure* series offer a glimpse into the more than 25,000 photographs that comprise the Museum's growing collection.

I am grateful to Robin Givhan, whose thoughtful essay "Living Beauty" is an excellent introduction to interpreting the images gathered here. She prompts us to see these photographs, some posed and others candid, with a sense of both empathy and kind curiosity, as well as suggesting another way to view style and to recognize its transformative powers. We are honored to have additional contributions to further enrich this selection of photographs: collector and photographer Adreinne Waheed, who made a generous donation of her archive of found photography, shares her story about searching, finding, and saving the remnants of lives that for one reason or another had been discarded (see pp. 38–41). Builder Levy shares his development as an artist and his inspirations for capturing beautiful moments in the "everyday" (see pp. 24–25), and Zun Lee recounts photographing a father and son on the Brooklyn Bridge and reveals his personal motivations for creating images of black fathers for his series *Father Figure* (see pp. 44–45).

This series has been created through the careful attention of many. Special acknowledgement goes to the Publications Team: Aaron Bryant, Curator of Photography; Rhea L. Combs, Curator of Photography and Film and Head of CAAMA; Laura Coyle, Head of Cataloging and Digitization, whose work makes the reproduction of these photographs possible; Michèle Gates Moresi, Supervisory Museum Curator of Collections and team leader on the project; Loren E. Miller, Curatorial Assistant and special assistant to the *Everyday Beauty* project; Douglas Remley, Editorial Assistant, whose coordination of the book series is essential to its success; and Jacquelyn Days Serwer, Chief Curator. In addition, I thank Rex M. Ellis, Associate Director for Curatorial Affairs, for his continuing support of this project.

We are fortunate to have the pleasure of co-publishing with D Giles Limited, based in London, England. At Giles, I particularly want to thank Dan Giles, Managing Director; Alfonso Iacurci, Designer; Allison McCormick and Louise Parfitt, Editorial Managers; Louise Ramsay, Production Manager; Jodi Simpson, copyeditor and proofreader; and Liz Japes, Sales and Marketing Manager. Finally, I would like to thank our entire Digitization Team for researching, cataloging, digitizing, and preparing all of the images and captions included in this volume.

I am proud to continue this landmark series of photography publications with images evoking such heartfelt human expression and to share this modest selection with the public. I hope you will be moved by the photographs at the Smithsonian and beyond.

Lonnie G. Bunch III
Founding Director
National Museum of African American History and Culture, Smithsonian Institution

Living Beauty

Robin Givhan
Fashion Critic, The Washington Post

There is a particular photograph amidst the many artifacts at the National Museum of African American History and Culture that exudes a special kind of grace and style. It's an image of regular folks doing an unremarkable thing. An elderly couple is leaving Sunday service at Metropolitan African Methodist Episcopal Church in Washington, D.C. (opposite; see also p. 46). The year is 1997, but when you consider the aesthetics, it could just as easily be 1950—or yesterday. The couple, he holding his walking stick and she clasping her church hat, look pleased but not giddy. The two seem rooted in the tough realities of daily life but also salved by spirituality. These two have not simply survived; they have lived.

The lady has a reserved yet open smile on her face. The gentleman looks pleasant and patient; he has no pronounced desire to be photographed but will submit, if you insist, because he knows that he's quite dapper—he only asks that you're fairly quick about it. He is wearing a suit and tie and she is wearing stockings with her sensible heels. The times may have allowed for a far more informal style of dress among the congregants in the pews but they were not going to succumb to it. No, sir. No, ma'am. He will keep his four-in-hand neatly in place with a proper tie bar and she will make the effort to wear hosiery even with its tendency to wrinkle at the ankles. This is no lesson in studied nonchalance. This couple is part of a generation for whom there was no advantage in dressing down. Respect began at home. Sometimes that was the only source of it.

"Everyday beauty" is not accidental style. It isn't happenstance. It is a conscious decision. A tool. Currency. Power. It is the result of African Americans having made a choice to proceed through life with dignity, confidence, and a sense of self. For black women, it is the intent to declare oneself beautiful and feminine when mainstream society views them as unattractive and

An Elderly Couple Departs Sunday Morning Services at Metropolitan AME Church, Washington, D.C., 1997; printed 2012 (detail)
Jason Miccolo Johnson

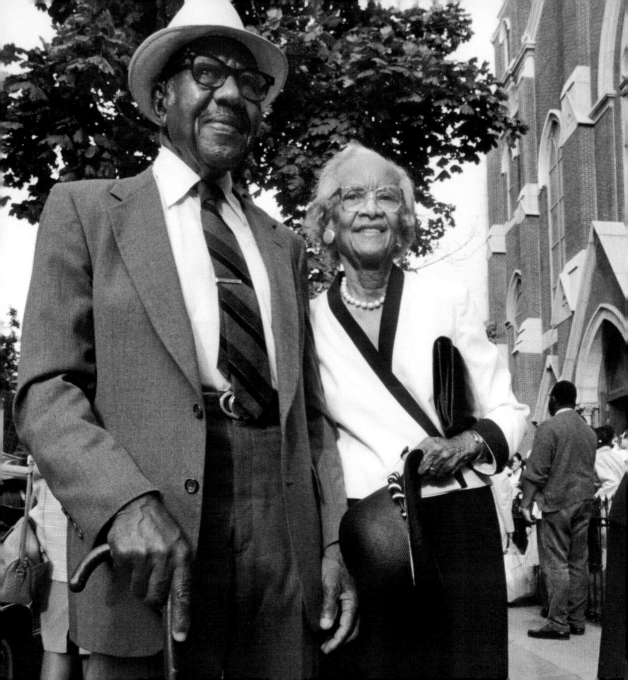

masculine. It is the belief in one's own authority when all the rules of society are focused on diluting it. It is an opportunity for a man to make himself known.

The anonymous men and women of the late nineteenth century stand with their hands formally clasped in front. High collars and elaborate waistcoats emphasize their rigid posture. They settled into this dignified posture as their image was slowly captured for history. The technology of the twentieth century allowed a quick-blinking shutter to capture a young man's vibrant swagger along with the glint of his gold chain (see p. 65). The stealthy ease of modern photography introduces us to a handsome woman wearing a caftan and palm-size earrings and delivering an I-really-have-no-time-for-you glance (see p. 17).

These photographs of "everyday beauty" are not remnants from special occasions or historical moments; they are snippets of the day-to-day. They capture the remarkable beauty of living, the luxury of another day, the majesty of the ordinary.

They capture the beauty of hope. The photograph of Eddie Mitchell, described as an "unemployed youth in Birmingham, Alabama," has him adjusting his tie (see p. 52). His shirt is a little too big, the barrel cuffs are turned up and then buttoned. It isn't perfect, but it

is clean. From that frozen moment, it's hard to know if he is at the beginning of a day or the end. Has he just knotted his tie? Or is he preparing to remove it? Does it matter? His head is tilted up as if he is giving himself a bit of a pep talk. He is moving forward, perhaps into the unknown or right back into a routine. Whichever it may be, his shoulders are straight. He is handsome.

In the sweet portrait of a young woman perched on a pier—a straw sun hat tilted back on her head and a fishing rod in her hand—she exudes the flirtatious charm of a Hollywood pin-up (see p. 26). The setting may feel natural, but her choices are clear and purposeful. Her little block-heeled mules are stylish and a bit risqué. Her smile suggests she is as certain of her own sex appeal as any famous starlet.

There are children in their Easter Sunday best and enjoying a candid moment among friends (see pp. 23 and 29), mere reflections of their elders now, but soon they will figure out who they are. And there are young adults with their status quo–defying Afros (see p. 55), refusing to groom or tame themselves into oblivion. The hair speaks. Big Daddy Kane has his high-top fade trimmed and shaped up, treated with the kind of attentive care reserved for a work of art forever in progress (opposite). The intimacy of a child braiding

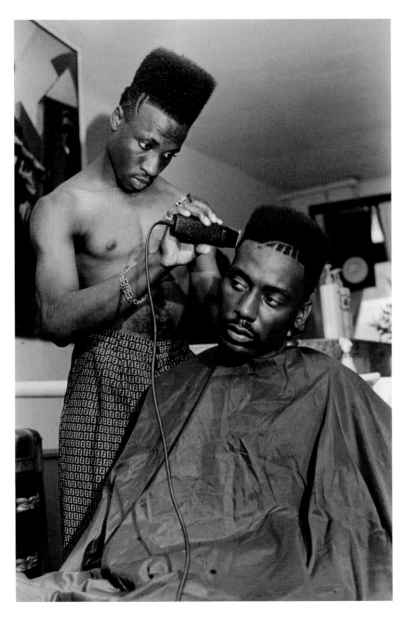

Big Daddy Kane getting
a shape-up, July 12, 1989;
printed 2003
Al Pereira

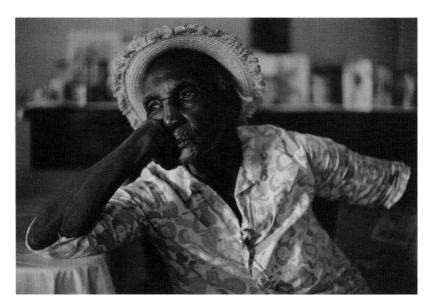

Miss Bertha, 1977; printed 2007
Jeanne Moutoussamy-Ashe

her grandmother's thick, silver hair is a silent conversation between generations (see p. 42). And the juxtaposition of Jacqueline Santiago and Cathy Lindsey—a wavy bob versus a pair of Afro puffs—is the story of America, colorism and gender stereotypes in a single frame (see p. 24).

"Everyday beauty" is the story of how we see ourselves and how we are seen. Look into the eyes of Miss Bertha (above). She's gazing into the distance, her chin cupped in her hand. A tiny gray braid peeks from below her straw hat. Her blouse, with its swirling pattern, buttons down the front. She looks tired, but fatigue hasn't overwhelmed her. Today, no one wants wrinkles. No one wants their face to reflect their age unless that age is 25. But Miss Bertha looks wizened. That may not be the beauty of modern Hollywood or Seventh Avenue, but it's the beauty of having survived. Of having lived. Day after day.

Everyday.

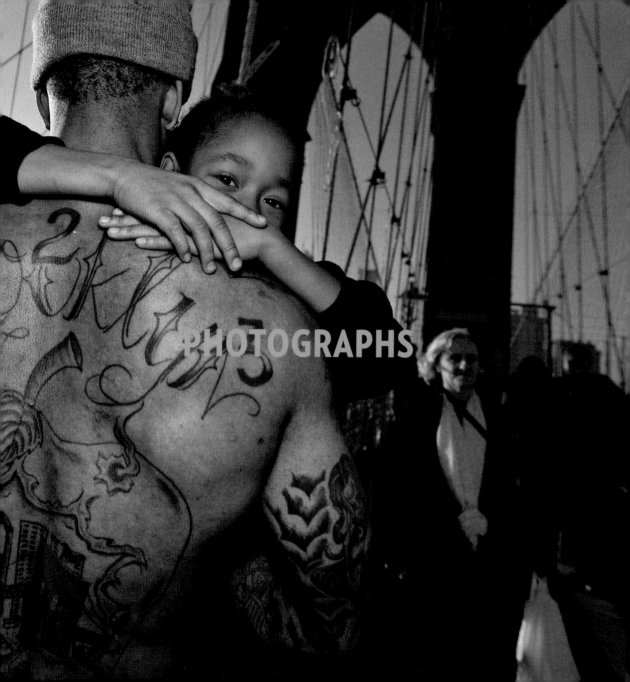

ACTIVISM

Black Panther Couple Listening, Free Huey Rally, DeFremery Park, Oakland, CA, No. 20, July 14, 1968; printed 2010
From the series **Black Panthers 1968**
Pirkle Jones

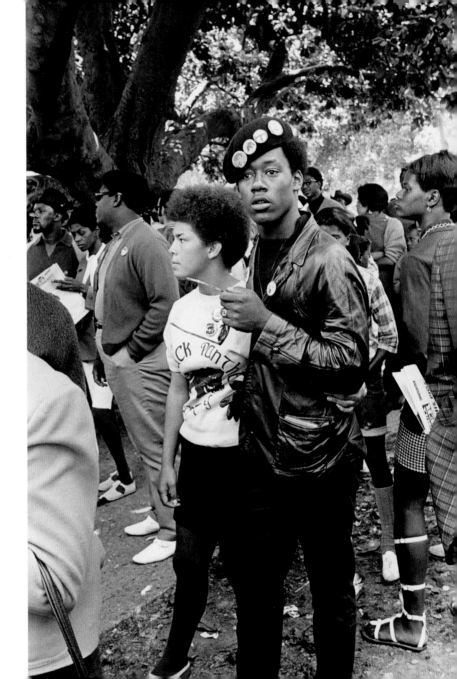

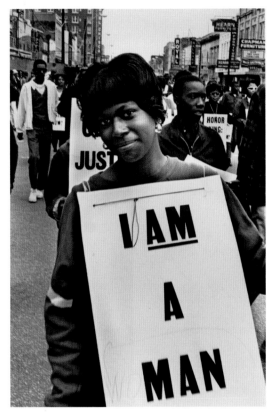

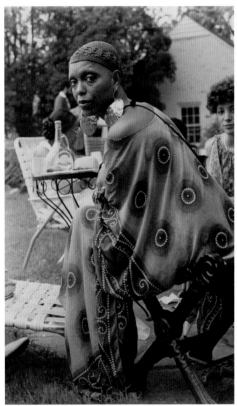

I AM A (WO)MAN, April 8, 1968;
printed 2016
**Martin Luther King Memorial
March for Justice and to End
Racism, Memphis, Tennessee**
Builder Levy

Untitled, January 1977
Milton Williams
—
Singer and dancer Jean Pace Brown,
wife of jazz musician and civil rights
activist Oscar Brown Jr.

Martin Luther King Memorial March for Union Justice and to End Racism, April 8, 1968; printed 2017
Memphis, Tennessee
Builder Levy

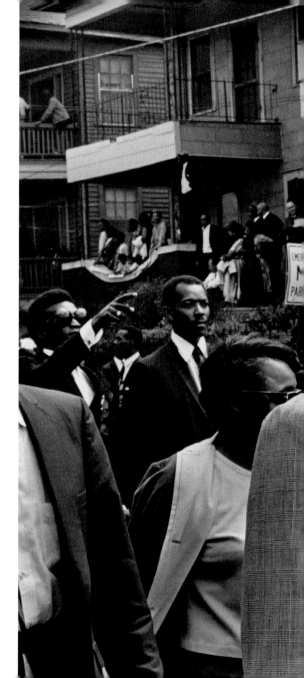

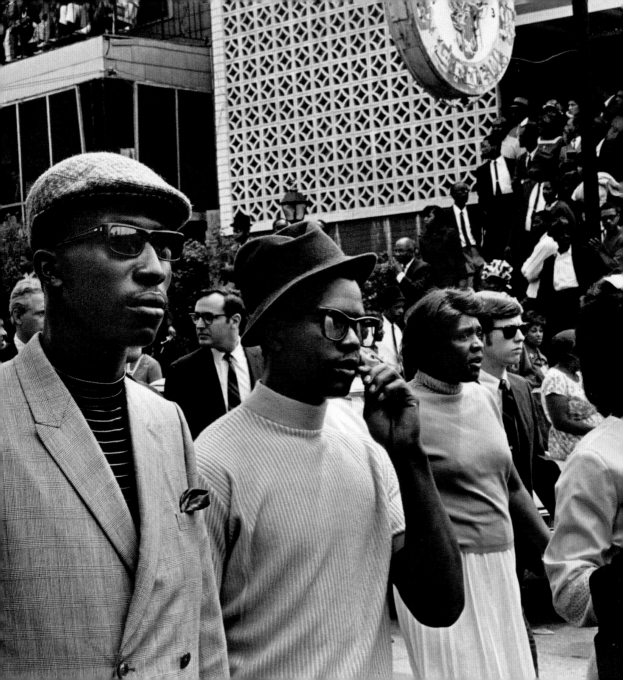

Denise Oliver, Young Lords Party Minister of Finance, at a Party rally, November 21, 1970
Jesse Steve Rose
—

Style can be a form of protest and proclamation. Over the years, people have used clothing and hairstyles to make political statements. In some instances, the way one adorns oneself supports middle-class aspiration and respectability politics, and in other instances, a person's clothing choice is a conscious tool of resistance. The Civil Rights Movement, the Black Power Movement, and the cultural nationalist movements all demonstrate different ways that personal aesthetics helped to inform and influence society and people's understanding of various activist movements.

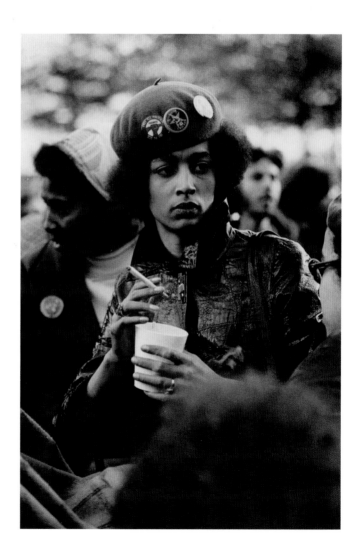

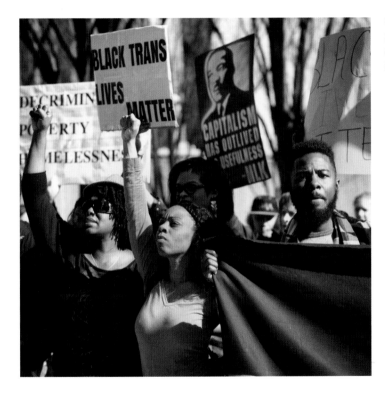

Untitled, 2015
From the series
#1960Now Portfolio (A)
Sheila Pree Bright

"When an individual is protesting society's refusal to acknowledge his dignity as a human being, his very act of protest confers dignity on him."

Bayard Rustin

STYLING

NYC, 1970s
Anthony Barboza

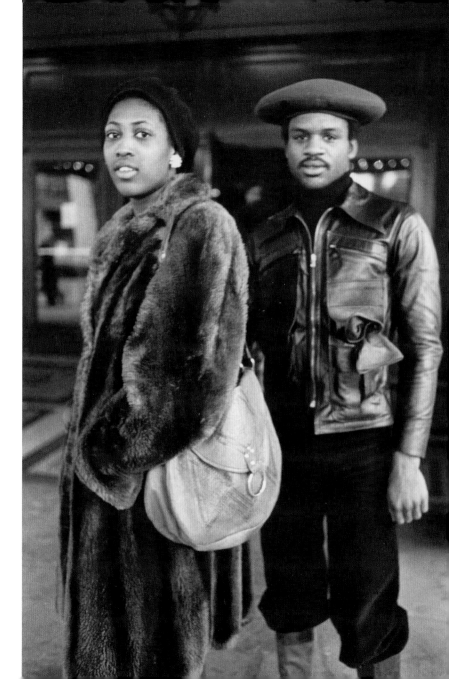

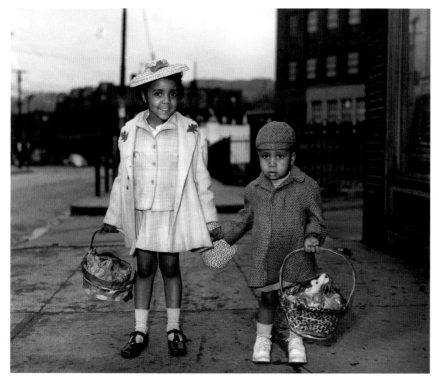

Mary Elizabeth and William Lewis holding Easter baskets, 1940–45
Charles "Teenie" Harris

Humanity in Pictures

I grew up during the Cold War and the McCarthy era in a family that encouraged art and believed we needed social change. By the 1960s, I thought of myself as an abstract expressionist, trying to make art like Willem de Kooning, Robert Rauschenberg, and John Chamberlain: full of directed spontaneity, raw energy, sensuality, and gritty vitality that spoke to me of real life. At that time, people in our nation were marching in the streets for civil rights at home and for peace in Vietnam. In communities throughout America, people were standing up for their humanity and dignity and struggling for social justice.

As an artist, I needed to find a way to have a direct connection to these realities. My explorations in paint and steel left me unsatisfied. My paintings and sculptures did not sufficiently express what was in my heart and mind, or adequately reflect the world outside. Making photographs was different. With the camera I was able to immerse myself directly in real life. I could abstract, compose, and intensify aspects of often chaotic, fluid reality within the rectangle of my viewfinder. With the release of the shutter, I could begin to physically create a new consciousness in and of the world. In the darkroom, I further intensify and complete the process in the

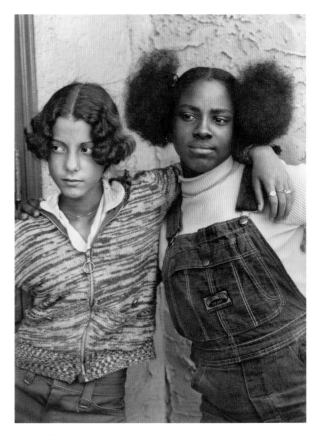

Jacqueline Santiago and Cathy Lindsey, 1976; printed 2016
Bushwick, Brooklyn, New York
Builder Levy

making of a photographic gold-toned gelatin silver or platinum print. I have been inspired by the many great photographers who, for more than a century, had been creating work grounded in realism infused with an intense humanity, among them Eugène Atget, Lewis Hine, Henri Cartier-Bresson, Paul Strand, Dorothea Lange, Walker Evans, Helen Levitt, W. Eugene Smith, Roy DeCarava, and Robert Frank. I have striven to be a part of and a contributor to that continuum.

During the thirty-four-and-a-half years that I worked with inner-city teenagers as a New York City teacher, my students shared some of their very intense lives, enriching my vision, photography, and life. Jacqueline Santiago and Cathy Lindsey, friends, were two of my students in a New York City alternative high school program. I had set up

a student social documentary photography workshop to supplement a basic academic program for our school. One day I brought in my second-hand 5x7 Deardorff View camera to show the students. Jackie and Cathy volunteered immediately to be subjects for a demonstration.

When I look at my photographs, I see my whole life, how much beauty and richness of humanity I have seen and experienced, and how fortunate I am to be able to share them with the world. While taking pictures, I have a heightened sense of being alive, sometimes imagining my images might inspire a world without exploitation, racism, sexism, hate, or war—a world of economic, social, and environmental justice, and democracy for all.

Builder Levy, 2017

"With the camera I was able to immerse myself directly into real life."

Builder Levy

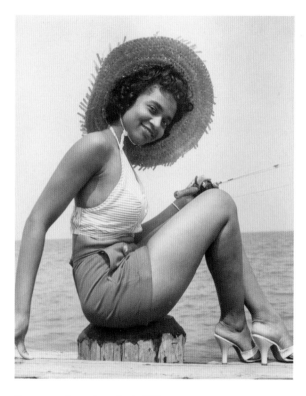

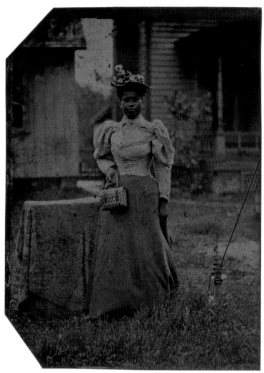

A woman in a straw hat sitting on a pier with a fishing rod, mid-20th century
Gaston L. DeVigne II

A woman wearing a dress with a hat and bag, 1890s
Unidentified photographer

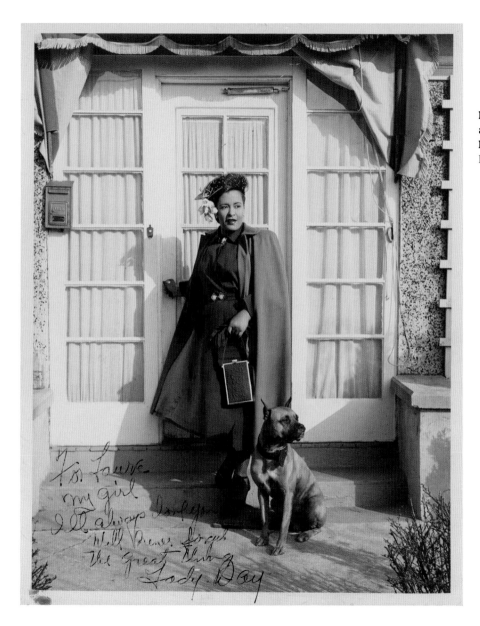

Billie Holiday and her dog Mister, ca. 1948
David Hawkins

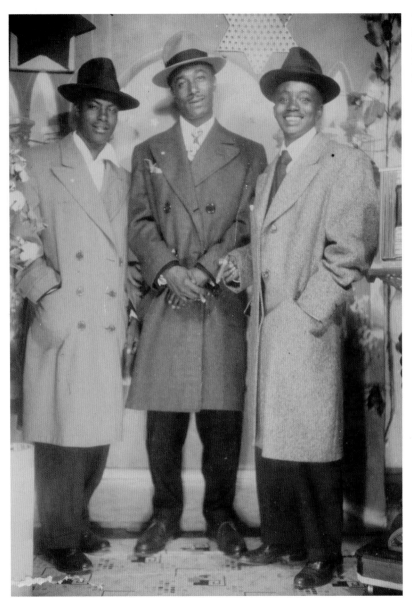

Three men standing in hats and overcoats, mid-20th century
Unidentified photographer

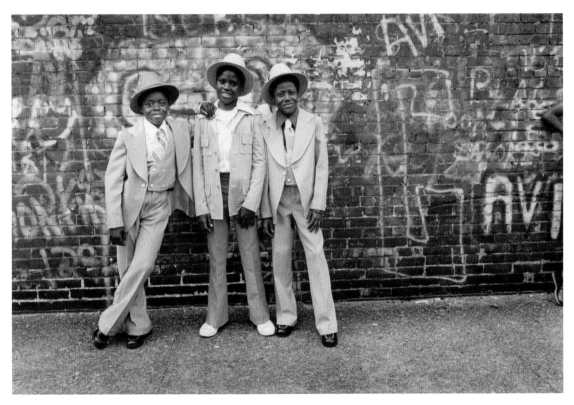

***Easter Sunday in
Harlem***, 1974
Anthony Barboza

A woman seated with a hat in her lap, mid-19th century
Unidentified photographer

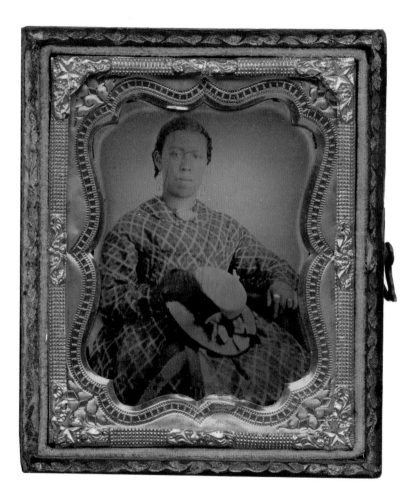

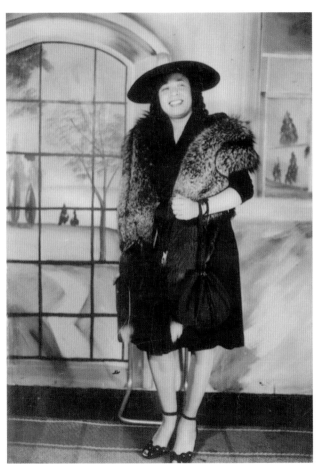

Mae Reeves wearing a fox stole and black hat,
1950
Unidentified photographer
—
Mae Reeves, an innovator in style and fashion, was a sought-after ladies' hat maker. Reeves opened Mae's Millinery in Philadelphia in 1940 after securing a loan from a local black-owned bank. With her savvy fashion sense and firm belief in self-expression, Reeves's clients included celebrities like Marian Anderson, Ella Fitzgerald, and Lena Horne. She was also popular among Philadelphian locals and travelers from out of town. Reeves is best known for her feathered, turban, and veiled hats, which conveyed pride and dignity for those who donned them.

JOY

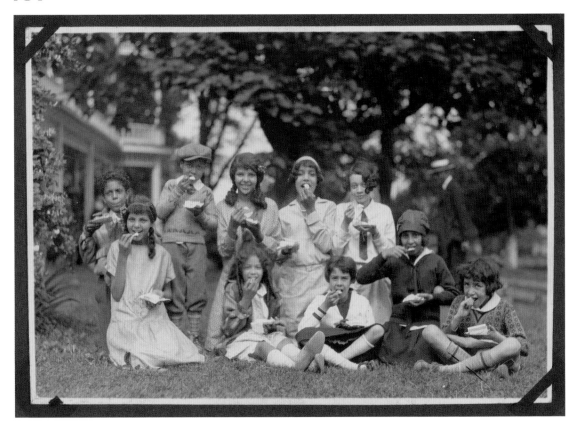

Children eating cake, 1920s
Addison Scurlock

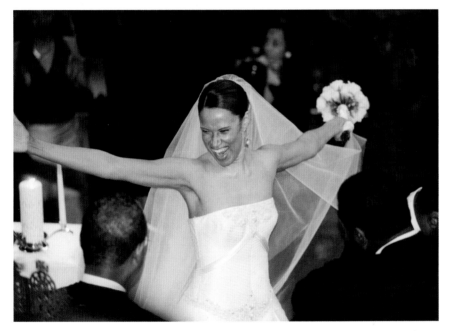

An Exuberant Bride, Tiffany Ellis, Is United in Matrimony to Calvin O. Butts IV, in the Historic Abyssinian Baptist Church, Officiated by Its Pastor (Calvin's Father), the Rev. Dr. Calvin O. Butts III, Harlem, New York, **2004**; printed 2012
Jason Miccolo Johnson

"I find, in being black, a thing of beauty: a joy; a strength; a secret cup of gladness."

Ossie Davis

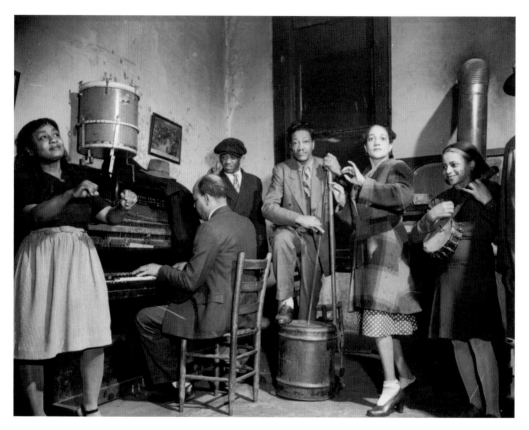

Beale Street, 1940s
Arthur Leipzig

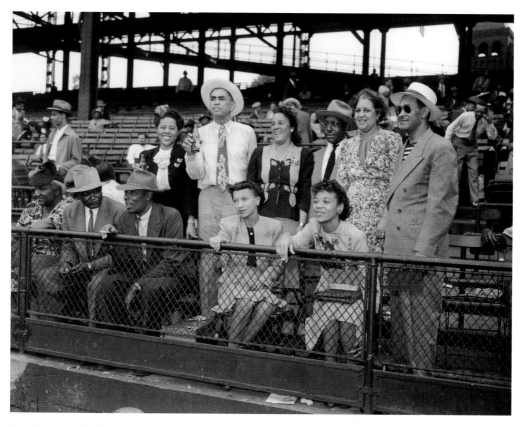

**Spectators at Forbes
Field**, 1945–50
Charles "Teenie" Harris

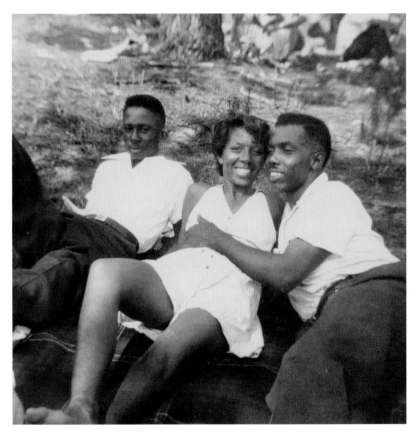

Symuel, Jew, and Harris lying on a blanket, 1951
Unidentified photographer

Untitled (Boys Playing in the Street), 1940s
Arthur Leipzig

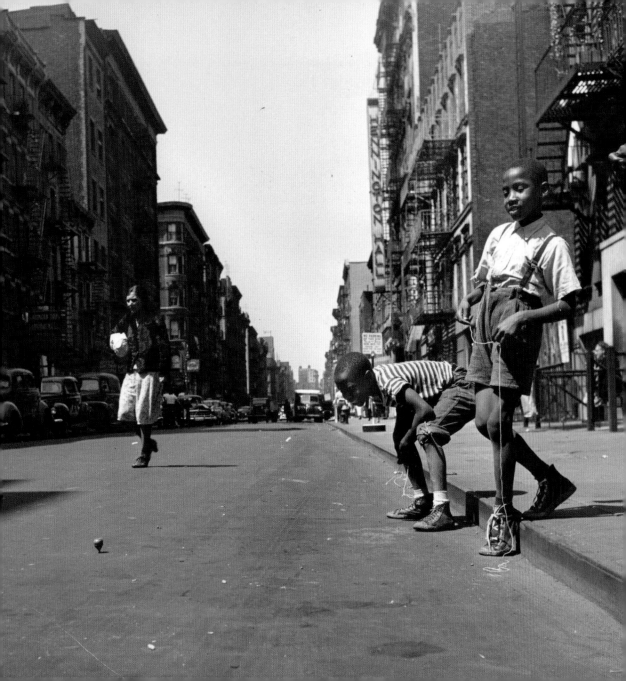

As Told by Us

I am drawn to the beauty and resilience of black people. I am interested in the untold story that a photograph holds. How do we memorialize our loved ones? Who remembers us when we are gone? What collective history can be learned from the stories of everyday black folks?

My journey toward creating my own collection occurred quite accidently. In 2009, I was visiting friends in Northeast Washington, D.C., when I happened to walk by a house that was being cleared out by city marshals. Among the pile of discarded belongings, there was a tattered old photo album. It looked to be from the 1950s and had photos spilling out of its sides. I took it home and leafed through its pages. I was captivated by the time capsule the album represented. It was packed with photos and ephemera of a life well lived. It occurred to me that this album, which represented a lifetime of memories, may be the only remnant of this family's legacy. And it had been tossed out. This photo album held someone's love and pain, someone's family history. The idea that these memories could just be thrown away was something I could not easily accept. I made it my mission to "rescue" as many of these "lost albums" as possible. I started buying old photos from garage and estate sales, thrift and pawn shops, and antique shows, as well as online. Eventually, I amassed over ten thousand "orphaned" photos depicting the everyday life of African Americans from the Civil War to present times. The images reflect individuals and families from all across the country and tell a national story.

In the collection is a 1918 scrapbook from a young African American woman attending Fisk University in Nashville, Tennessee. Tattered and fragile, with hand-written captions and photos cut into shapes and letters, this album gives a wonderful glimpse of how her personal history was shaped and memories were created.

This collection offers a counter-narrative to the depictions of African Americans that reinforce negative stereotypes. It aims to honor the memories and legacies of our elders by giving a voice to ordinary, everyday black folks and recognizing that each of us plays a role in our collective history. We are here and have always been here—helping to build and shape the country. Rather than someone else's narrative, the collection represents our stories told by us.

Adreinne Waheed, 2017

Dittie reclining on a couch,
December 31, 1951
Unidentified photographer

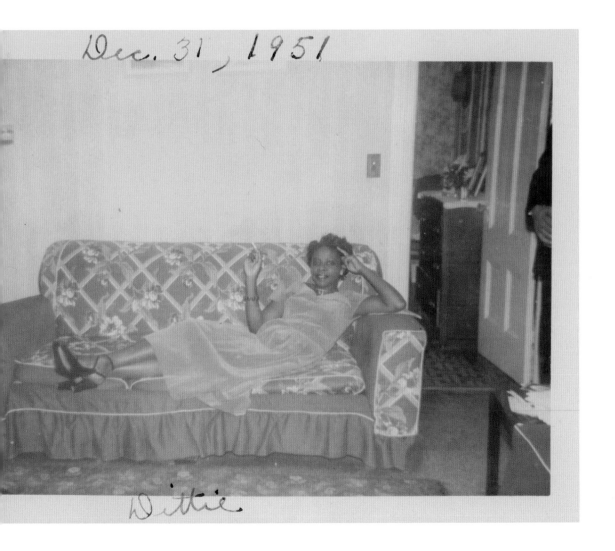

**Photographs from the Waheed
Photo Archive**, 20th century
Unidentified
photographers

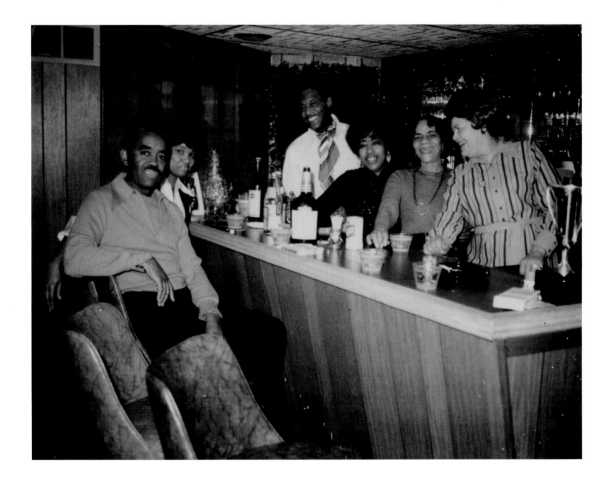

TENDERNESS

Quilter Hettie Barnes with Her Granddaughter on Her Front Porch in Doloroso, near the Homochitto River in Wilkinson County, Mississippi, 1976
From the series
Mississippi Folklife Project
Roland L. Freeman

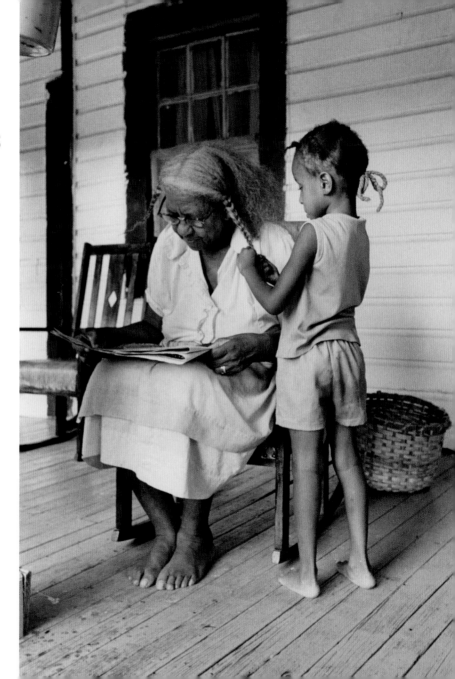

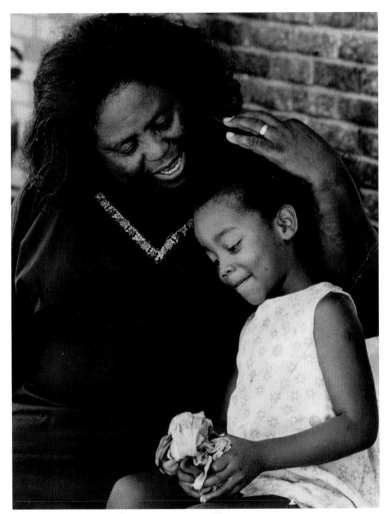

Untitled, 1971
Louis H. Draper
—
Civil rights activist
Fannie Lou Hamer and
her husband Perry "Pap"
Hamer wanted a family.
However, Hamer was
unable to have children:
like many black women
in the South at the time,
she had received what
she called a "Mississippi
appendectomy," or forced
sterilization. Instead, the
couple adopted two local
girls, Dorothy Jean and
Virgie, whose families
could not afford to care
for them. Dorothy Jean
tragically died young,
leaving behind her
two daughters, Lenora
and Jacqueline. The
Hamers also adopted
and raised their young
granddaughters, one of
whom is pictured here in
this tender moment.

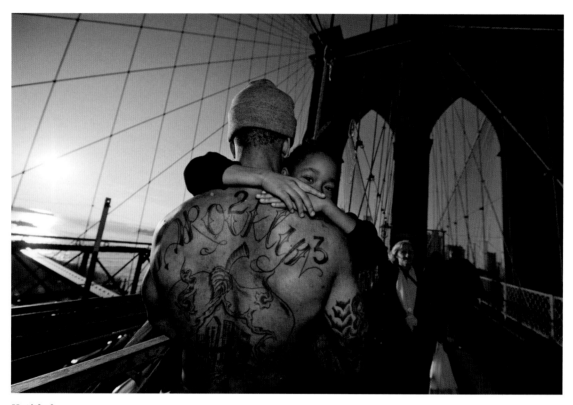

Untitled*,*
November 2012
From the series
Father Figure
Zun Lee

A Child's Trust—A Father's Promise

"Dad, I'm tired," complained Fidel to his father Jerell as we hiked across the Brooklyn Bridge on an unusually balmy November evening. Jerell gently lifted his son into his arms as I was preparing to press the shutter. I'll always remember the look in Fidel's eyes, a self-assured glance that said, "My dad always has my back"—a fleeting moment that does not register in the mainstream imagination; a glimpse into a relationship that is not supposed to exist, if we believe the prevalent narrative.

Pundits and politicians routinely blame black fathers' absence for much of what they regard as dysfunctional in African American communities. Research has shown that black fathers are no less present in their kids' lives than fathers in other ethnic groups, yet stereotypes continue to persist. Lost in the hyperbole is the everyday dad who may not fit conventionally accepted notions of black fatherhood, who often remains invisible in pop culture, politics, and public discourse.

The story of these unsung heroes is deeply personal. In my childhood, I was nurtured by African American men who were not blood relatives but who softened the abuse and neglect I experienced from my biological father. For the project *Father Figure*, my collaborators allowed me to immerse myself in their lives for years. Their efforts reminded me of the love and care I had received back in the day—a love that unfolds not in big iconic moments but in the interstices of everyday life. The quiet power of these moments is what my work attempts to foreground. Collectively, these moments bear witness to a different narrative, a narrative that I hope enables us to embrace the complexities of black family life without negating black men's capacity for love and affection.

Zun Lee, 2017

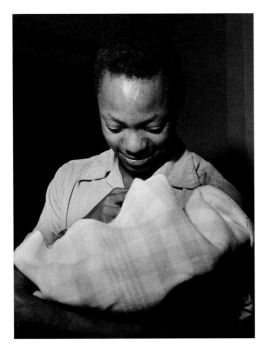

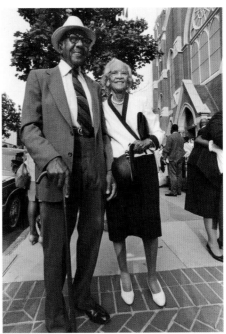

Untitled, 1946–48
From the series **The Way of Life
of the Northern Negro**
Wayne F. Miller

*An Elderly Couple Departs
Sunday Morning Services
at Metropolitan AME
Church, Washington, D.C.,
1997*; printed 2012
Jason Miccolo Johnson

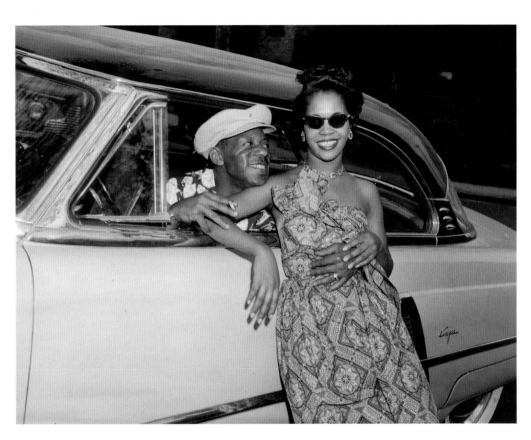

***Man in Car Flirting
with Woman****, ca. 1955
Charles "Teenie" Harris

Smoke and the Lovers, 1992
Frank L. Stewart

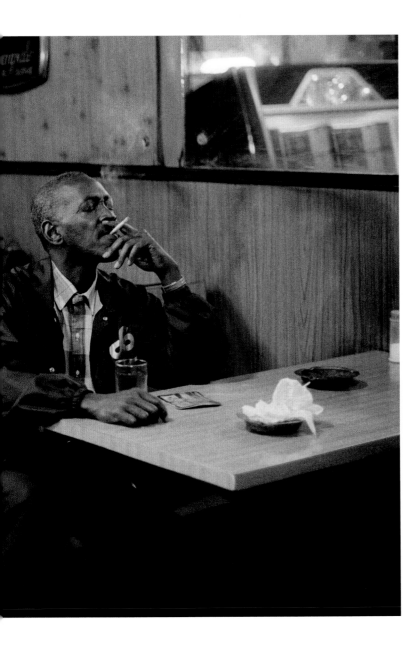

A Special Point of View:
The Scurlock Family Archive

Addison Scurlock began working as a
photographer at the dawn of the twentieth
century. In 1900, at age 17, Addison moved with
his family from Fayetteville, North Carolina, to
Washington, D.C. Shortly after their move, he
apprenticed for three years with Moses Rice
to learn the craft of photography, a skill he
would eventually pass on to his sons, Robert
and George.

In 1911, Addison opened the Scurlock
Studio at Ninth and U Streets in Northwest
Washington, D.C., the heart of the city's
burgeoning black community. For nearly eight
decades, the studio operated as a place to
capture the dreams and dignity of individuals,
families, and communities. At the time
Scurlock started taking pictures, mainstream
perceptions of the black community were
often reduced to stereotypes and caricatures.
However, Scurlock's work punctuated a lived
experience that highlighted a vibrant African
American community engaged in a variety
of activities, social clubs, and civic duties. His
signature aesthetic emphasized light, shadow,
posing, and retouching to create a look of
respectability and dignity.

Over the years, Addison Scurlock
became a highly sought-after photographer
in the D.C. area. In addition to being the official
photographer for Howard University, he was
very active in documenting community life—

**Mamie Fearing
Scurlock**, ca. 1912
Addison Scurlock

Mary and Warren Fearing, ca. 1912
Addison Scurlock

birthdays, graduations, anniversaries, and other social gatherings. It was even said that if the Scurlock Studio did not take a picture at your wedding, you were not really married.

The photographs highlighted here are part of the Museum's Scurlock Family Archive and are particularly special because they feature glimpses of the family behind the camera. The archive includes images of Addison's wife of 52 years, Mamie Fearing Scurlock. This picture (opposite) was probably taken just a year after the Scurlock Studio opened, when a young Mamie and Addison were still courting. The archive also includes images of extended family (above), along with Addison and Mamie's children in various stages of childhood and adulthood (see p. 32). Many of the photographs were taken by Addison, or in later years by one of his sons, and show the family engaging in everyday life: celebrating special occasions, enjoying family vacations, and even documenting the growth and changes of the Scurlock business—and the city—over time. This archive of one of the country's most important photographers provides us with an intimate view of the artist's life, as well as a better understanding of the Scurlock legacy.

Rhea L. Combs, 2017

ATTITUDE

Eddie Mitchell,
Unemployed Youth,
Birmingham,
Alabama, 1940
Arthur Rothstein

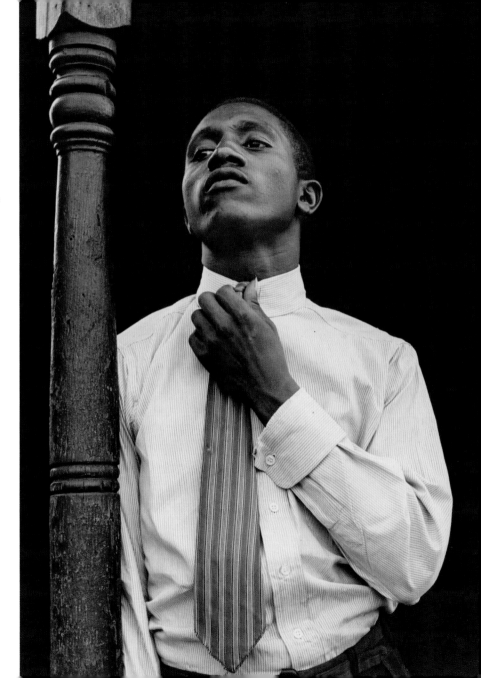

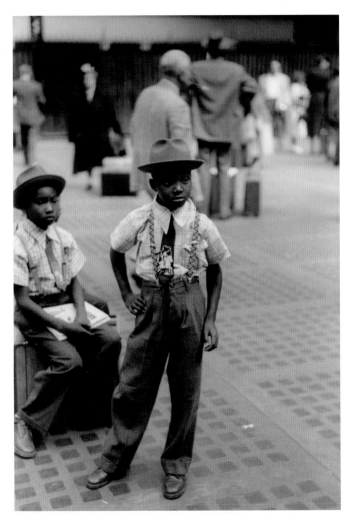

Fashionable Little Boy at Penn Station, NY, 1947; printed 2017
From the **Penn Station Series**
Ruth Orkin

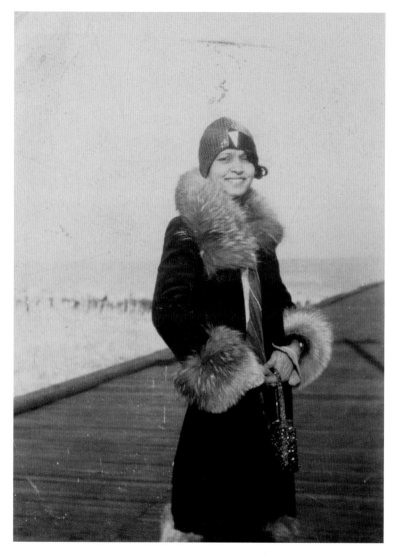

**A woman standing on
a boardwalk**,
early 20th century
Unidentified
photographer

*"With confidence,
you have won before
you have started."*

Marcus Garvey

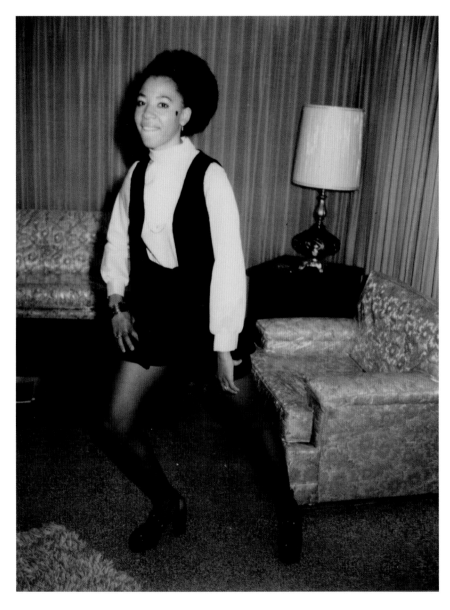

A woman wearing a black and white outfit, 1970s
Unidentified photographer

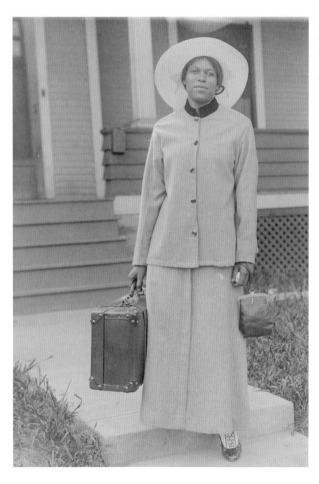

A woman holding a travel bag, early 20th century
Unidentified photographer

Well-Dressed Woman at Penn Station, NY, 1947; printed 2017
From the **Penn Station Series**
Ruth Orkin

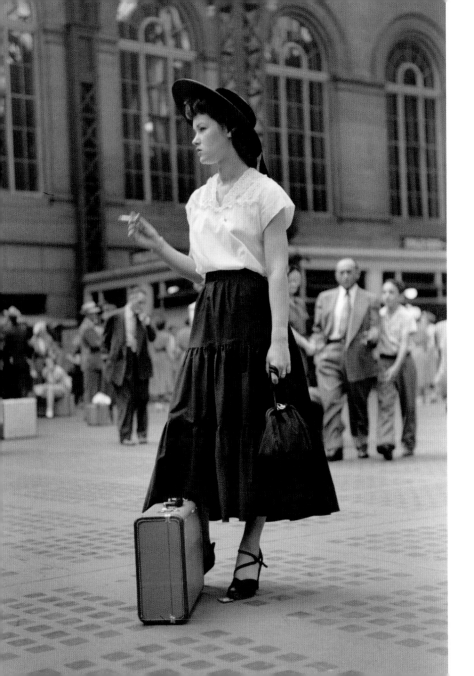

Untitled, July 25, 2015
Devin Allen

DIGNITY

Florida, 1960s
Anthony Barboza

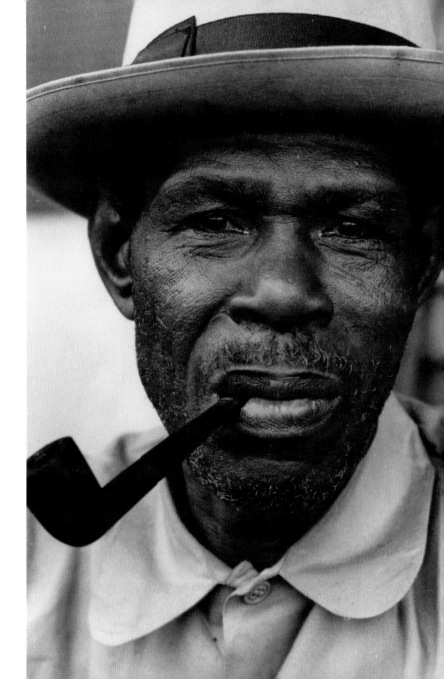

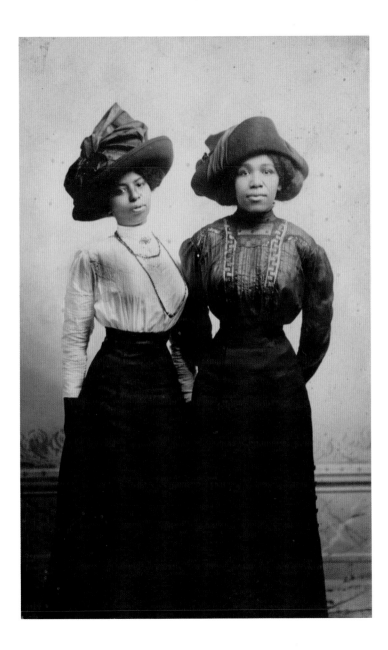

Harriet Tubman's great-nieces, Eva Stewart Northrup and Alida Stewart, ca. 1913
Unidentified photographer

—

Activist and abolitionist Harriet Tubman had a large extended family who occasionally stayed with her in her Auburn, New York, home. Tubman helped to raise Eva Katherine "Katy" Stewart Northrup and Alida Maud Stewart from the time they were very young. This picture may have been taken when the cousins attended the inauguration of the twenty-eighth president, Woodrow Wilson.

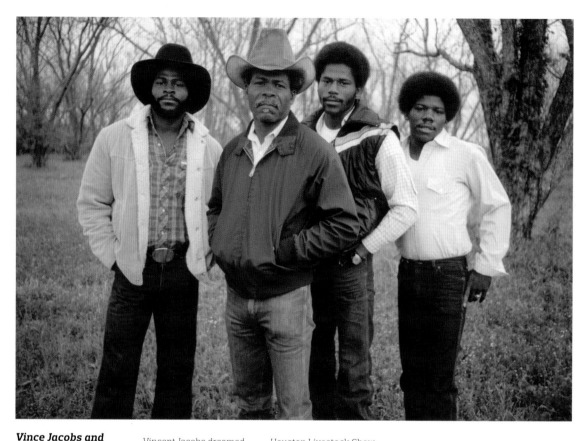

Vince Jacobs and His Boys, September 1983; printed 2013
From the series
Cowboys: Reconstructing the American Myth / En Recuerdo de Henry
Tony Gleaton
—

Vincent Jacobs dreamed of being a cowboy ever since he was a teenager. Fighting against racism and bias, he competed in rodeos and became one of the first black performers to ride in the Houston Livestock Show and Rodeo. Photographer Tony Gleaton, who worked throughout his career to document the beauty of the African diaspora, depicts Jacobs here with three of his sons.

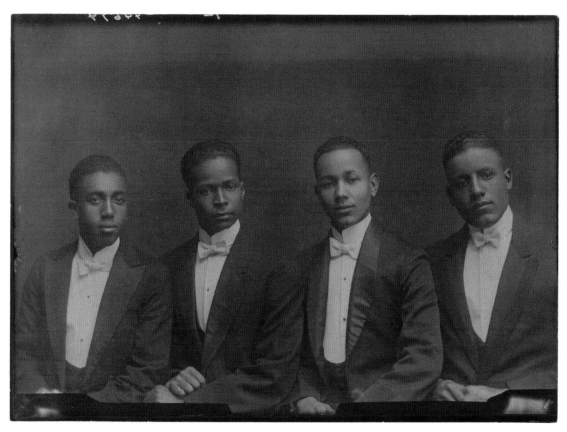

Four men dressed in tuxedos, early 20th century
Calvert Brothers Studio

Untitled, 1946–48
**A railroad
passenger car
maintenance man**
From the series
**The Way of
Life of the
Northern Negro**
Wayne F. Miller

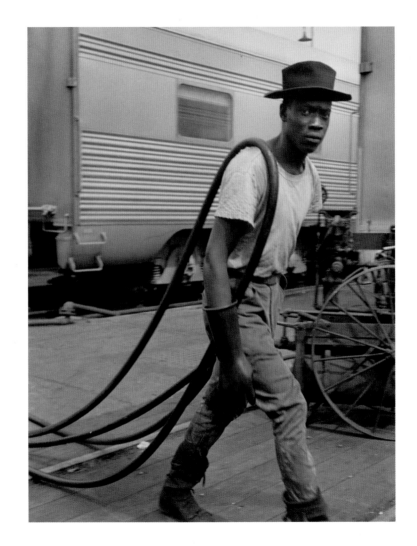

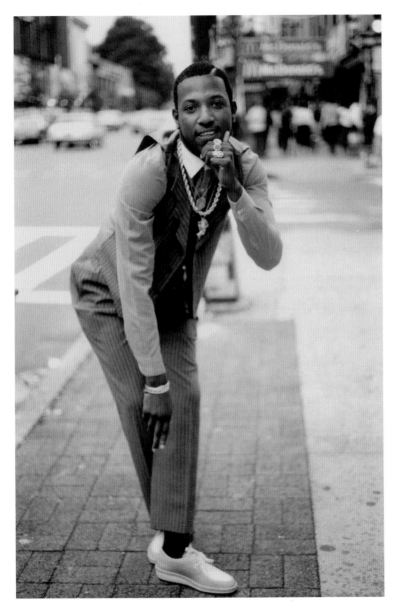

Rude Boy, early
1980s; printed 2010
Jamel Shabazz

**Mayme Griffin posing
with a book**, 1914;
scanned 2012
John Johnson
—
Photographer John
Johnson documented
the black community
in Lincoln, Nebraska,
from 1910 to 1925.
He often employed a
portable backdrop, using
shadows from porches
to control the lighting.
Here, he shows Mayme
L. Griffin (also known
as Mamie) holding *The
Wife of Monte Cristo*, an
unofficial sequel to writer
Alexandre Dumas's *The
Count of Monte Cristo*.
Mayme poses with a book
whose cover features a
conventional but insipid
type of female beauty,
which contrasts with
Mayme's powerful and
defiant demeanor.

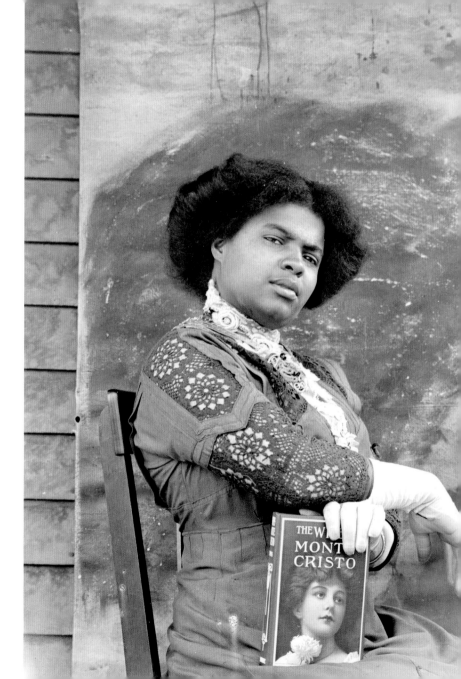

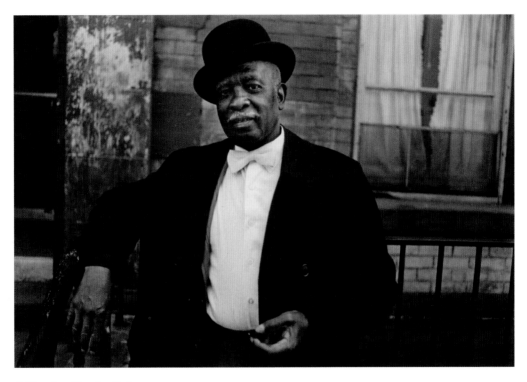

A Man in a Bowler Hat,
1976; printed 2005
From the series
Harlem, USA
Dawoud Bey

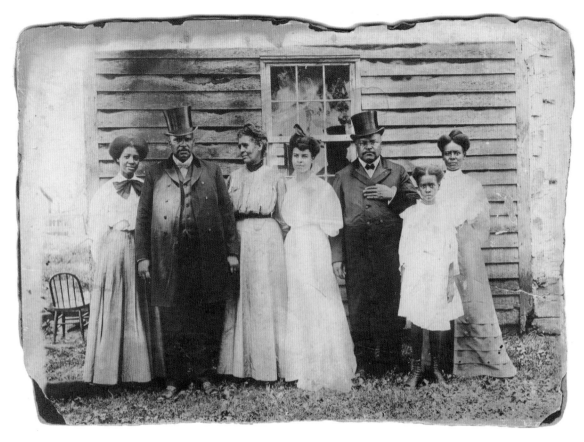

The Stevens Family outside their home in Linn Creek, Missouri, ca. 1905
Unidentified photographer
—

Henry Stevens Sr. was born into slavery in Lexington, Kentucky, and taken to Missouri sometime in the 1840s. According to family lore, Stevens hid his four children in Missouri caves during the Civil War to avoid their being kidnapped and sold south. After Emancipation, Stevens settled in the small town of Linn Creek, Missouri, and became an independent farmer. Stevens and his family made a new life in Linn Creek, and his children and grandchildren, photographed here, continued to live and thrive in the town where he settled.
Pictured (left to right): Della F. Stevens, Charles T. Stevens, Eliza Bradshaw Stevens, Eva E. Stevens, William A. Stevens, Florence E. Stevens, and

Index

Jason Miccolo Johnson
An Elderly Couple Departs Sunday Morning Services at Metropolitan AME Church, Washington, D.C., 1997; printed 2012
gelatin silver print
H × W (Image and Sheet):
19¾ × 15⅞ in. (50.2 × 40.3 cm)
2012.141.38
© Jason Miccolo Johnson
Pages 10 and 46

Jason Miccolo Johnson
An Exuberant Bride, Tiffany Ellis, Is United in Matrimony to Calvin O. Butts IV, in the Historic Abyssinian Baptist Church, Officiated by Its Pastor (Calvin's Father), the Rev. Dr. Calvin O. Butts III, Harlem, New York, 2004; printed 2012
gelatin silver print
H × W (Image and sheet):
15¹⁵⁄₁₆ × 19¾ in. (40.5 × 50.2 cm)
2012.141.31
© Jason Miccolo Johnson
Page 33

John Johnson
Mayme Griffin posing with a book, 1914; scanned 2012
digitized negative
2012.56.1.27
© Douglas Keister
Page 66

Pirkle Jones
Black Panther Couple Listening, Free Huey Rally, De Fremery Park, Oakland, CA, No. 20, July 14, 1968; printed 2010
From the series **Black Panthers 1968**
gelatin silver print
H × W (Image and Sheet):
28 × 22 in. (71.1 × 55.9 cm)
Gift of the Pirkle Jones Foundation
2012.83.3
© 2011 Pirkle Jones Foundation
Page 16

William J. Kuebler Jr.
A woman, 1885–92
gelatin silver cabinet card
H × W (Image and Mount):
6⁹⁄₁₆ × 4¼ in. (16.7 × 10.8 cm)
2011.155.76.5
Page 8

Zun Lee
Untitled, November 2012
From the series **Father Figure**
digital image
Gift of Zun Lee
2016.52.3
© Zun Lee
Pages 15 and 44

Arthur Leipzig
Beale Street, 1940s
gelatin silver print
H × W (Image and Sheet):
7⅝ × 9½ in. (19.4 × 24.1 cm)
Gift of Mildred Leipzig in memory of Arthur Leipzig
2017.60.2
© Arthur Leipzig
Page 34

Arthur Leipzig
Untitled (Boys Playing in the Street), 1940s
gelatin silver print
H × W (Image and Sheet):
10½ × 10⅜ in. (26.7 × 26.4 cm)
Gift of Mildred Leipzig in memory of Arthur Leipzig
2017.60.4
© Arthur Leipzig
Page 36

Builder Levy
I AM A (WO)MAN, April 8, 1968; printed 2016
Martin Luther King Memorial March for Union Justice and to End Racism, Memphis, Tennessee
Nelson's gold-toned gelatin silver print
H × W (Image):
13 × 8⅝ in. (33 × 21.9 cm)
Gift of Arnika Dawkins and the Arnika Dawkins Gallery
2017.43.2
© Builder Levy
Page 17

Builder Levy
Jacqueline Santiago and Cathy Lindsey, 1976; printed 2016
Bushwick, Brooklyn, New York
platinum print
H × W (Image):
13 × 9¾ in. (33 × 24.8 cm)
Gift of Arnika Dawkins and the Arnika Dawkins Gallery
2017.43.1
© Builder Levy
Page 24

Builder Levy
Martin Luther King Memorial March for Union Justice and to End Racism, April 8, 1968; printed 2017
Memphis, Tennessee
Nelson's gold-toned gelatin silver print
H × W (Image and Sheet):
9 × 12⅞ in. (22.9 × 32.7 cm)
Gift of Builder Levy
2017.43.5
© Builder Levy
Page 18

Wayne F. Miller
Untitled, 1946–48
A railroad passenger car maintenance man
From the series **The Way of Life of the Northern Negro**
gelatin silver print
H × W (Image and Sheet):
13¼ × 10⅜ in. (33.7 × 26.4 cm)
2009.24.8
© Wayne Miller/Magnum Photos
Pages 6 and 64

Wayne F. Miller
Untitled, 1946–48
From the series **The Way of Life of the Northern Negro**
gelatin silver print
H × W (Image and Sheet):
13¼ × 10⅝ in. (33.7 × 26.2 cm)
2009.24.30
© Wayne Miller/Magnum Photos
Page 46

Jeanne Moutoussamy-Ashe
Miss Bertha, 1977; printed 2007
gelatin silver print
H × W (Image and Sheet):
20 × 24 in. (50.8 × 61 cm)
Generously donated by Bank of America Corporation
2014.310.9
© Jeanne Moutoussamy-Ashe
Page 14

Ruth Orkin
Fashionable Little Boy at Penn Station, NY, 1947; printed 2017
From the **Penn Station Series**
gelatin silver print
H × W (Image and Sheet):
14 × 10⅞ in. (35.6 × 27.6 cm)
2017.50.1
© Orkin/Engel Film and Photo Archive
Page 53

Ruth Orkin
Well-Dressed Woman at Penn Station, NY, 1947; printed 2017
From the **Penn Station Series**
gelatin silver print
H × W (Image and Sheet):
14 × 11⅞ in. (35.6 × 30.2 cm)
2017.50.2
© Orkin/Engel Film and Photo Archive
Page 56

Al Pereira
Big Daddy Kane getting a shape-up, July 12, 1989; printed 2003
gelatin silver print
H × W (Image and Sheet):
13¹⁵⁄₁₆ × 10¹⁵⁄₁₆ in. (35.4 × 27.8 cm)
2015.132.267
© Al Pereira
Page 13

Jesse Steve Rose
Denise Oliver, Young Lords Party Minister of Finance, at a Party rally, November 21, 1970
gelatin silver print
H × W (Image and Sheet):
13¹⁵⁄₁₆ × 11 in. (35.4 × 27.9 cm)
2014.109.7.4
Page 20

Unidentified photographer
A woman wearing a dress with a hat and bag, 1890s
tintype
H × W:
3⅞ × 2½ in. (9.8 × 6.4 cm)
Gift of Oprah Winfrey
2014.312.142
Page 26

Milton Williams
Untitled, January 1977
gelatin silver print
H × W (Image and Sheet):
8⅛ × 4¹⁵⁄₁₆ in. (20.6 × 12.5 cm)
Gift of Milton Williams Archives
2011.15.374
© Milton Williams
Page 17